Wake Up Sun

by

Katie Sharpe

AuthorHouse™
1663 Liberty Drive
Bloomington, IN 47403
www.authorhouse.com
Phone: 833-262-8899

Because of the dynamic nature of the Internet, any web addresses or links contained in this book may have changed since publication and may no longer be valid. The views expressed in this work are solely those of the author and do not necessarily reflect the views of the publisher, and the publisher hereby disclaims any responsibility for them.

Any people depicted in stock imagery provided by Getty Images are models, and such images are being used for illustrative purposes only.
Certain stock imagery © Getty Images.

This book is printed on acid-free paper.

ISBN: 978-1-4389-2897-5 (sc)

Print information available on the last page.

Published by AuthorHouse 02/27/2021

authorHOUSE®

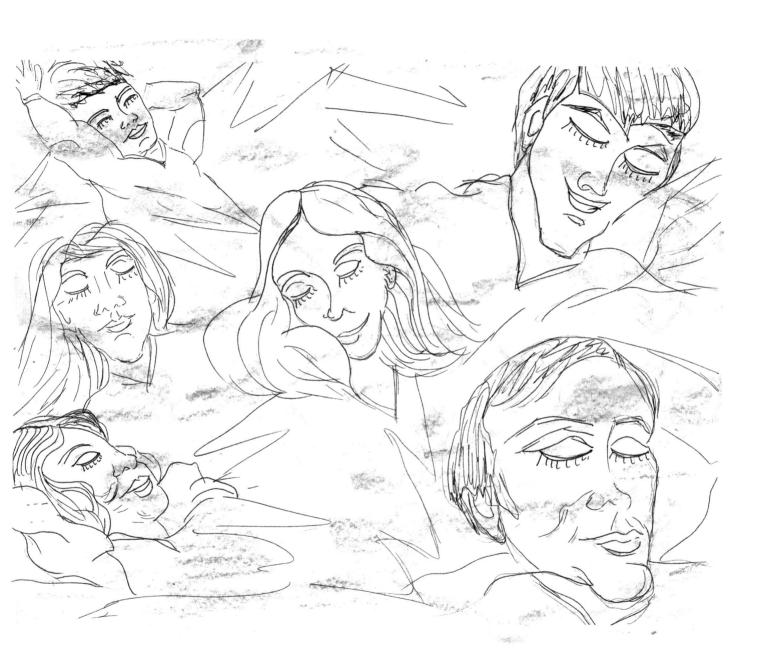

All is quiet.
All is calm.
Let's go, world!
It's time for some fun.

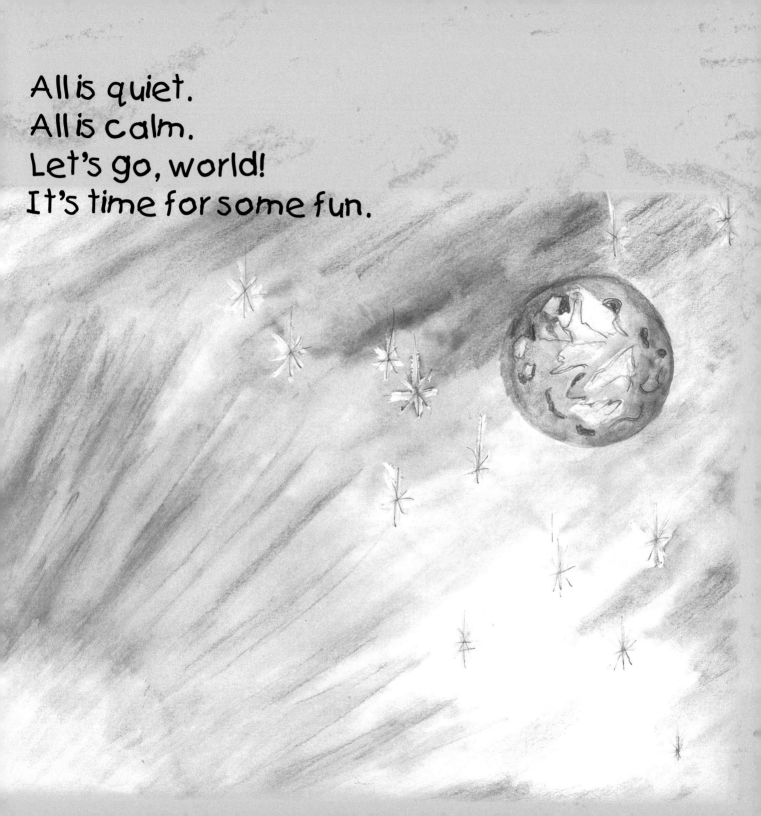

"Wake up, sun. Wake up!"
A voice is calling,
"Wake up! Wake up!"

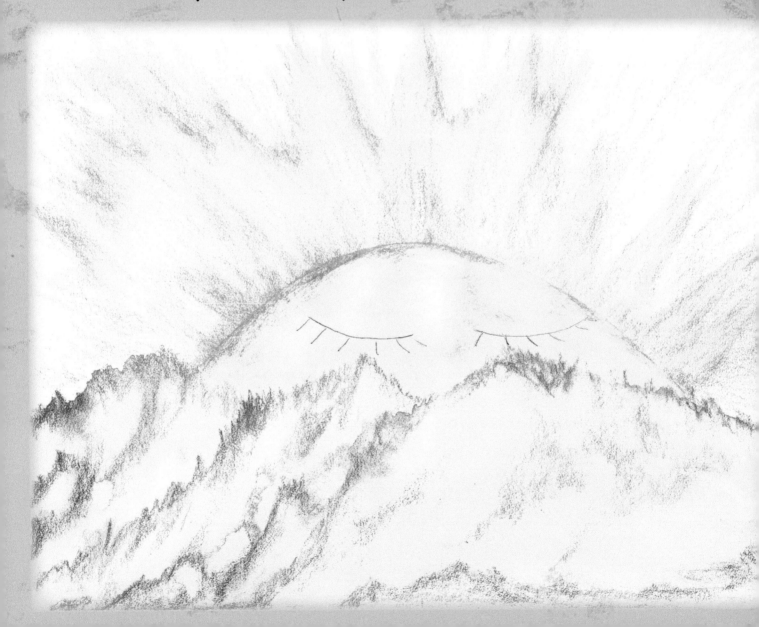

I wake each morning
with a big, happy smile.
But sometimes I'm sad
when clouds cover me up.

Wake up, house.
Wake up, friends.

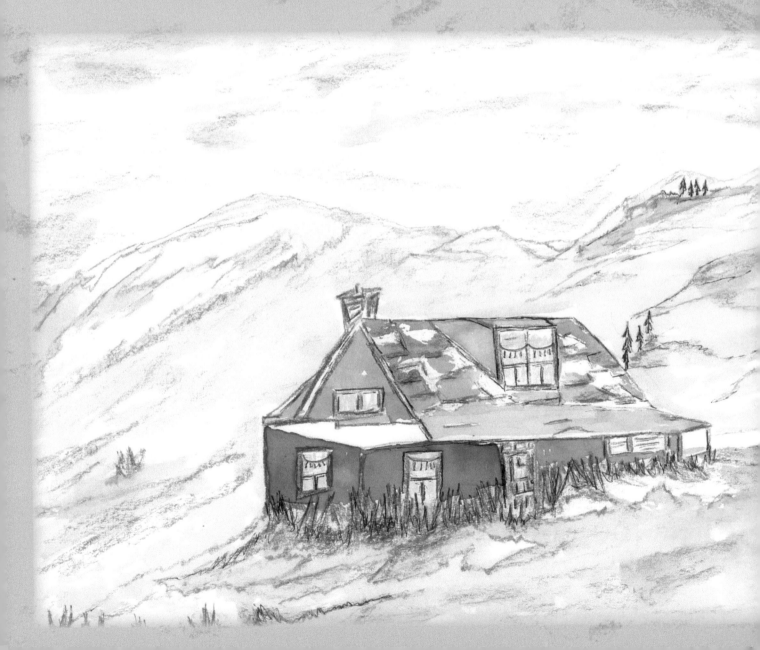

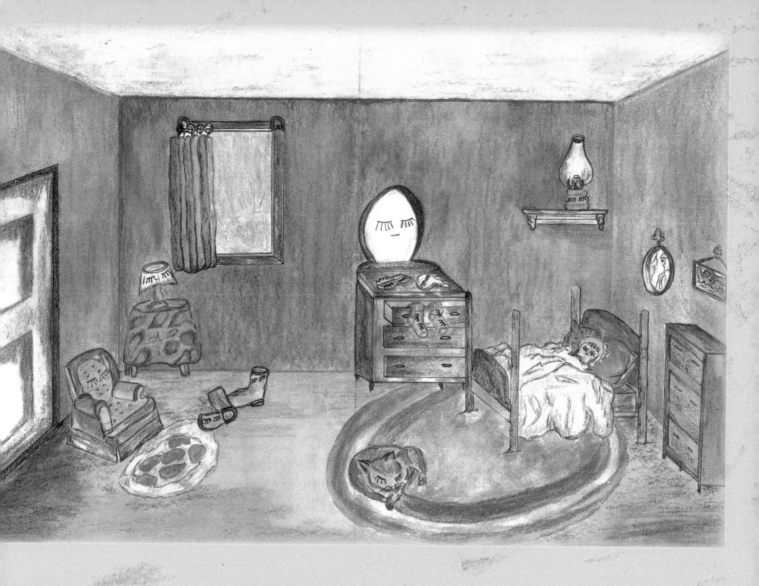

The sun is creeping in.
Ask each room to
get up soon.

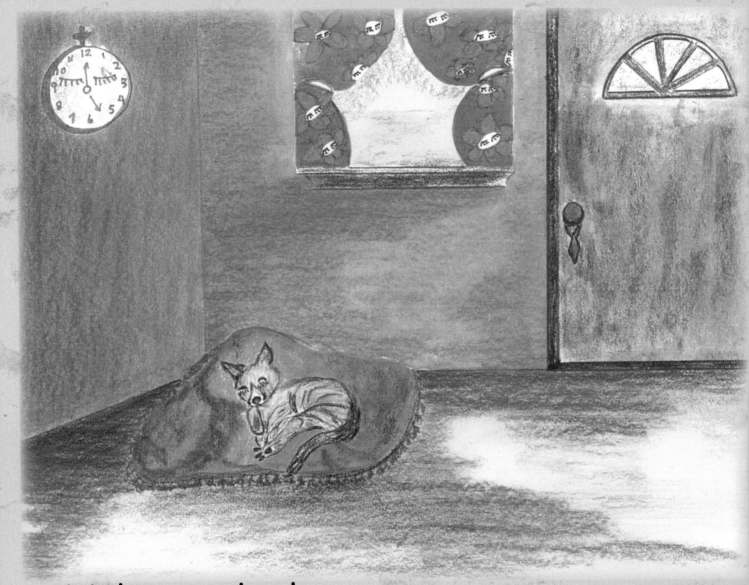

Wake up, clock.
Wake up, Mingo.
Time to wake up!
Even the flowers on the curtain window.

Wake up, Rover!
Time for your walk.

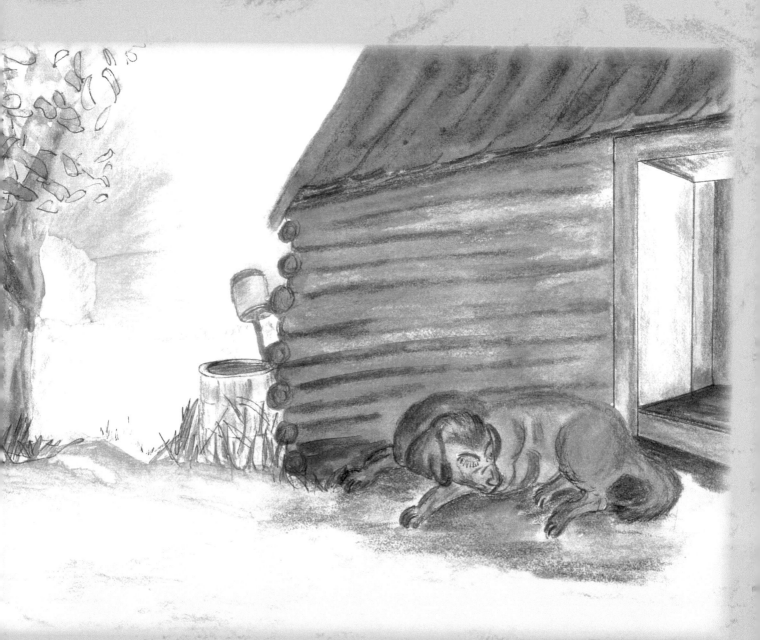

Wake up, cows!
Milk is needed at the market.

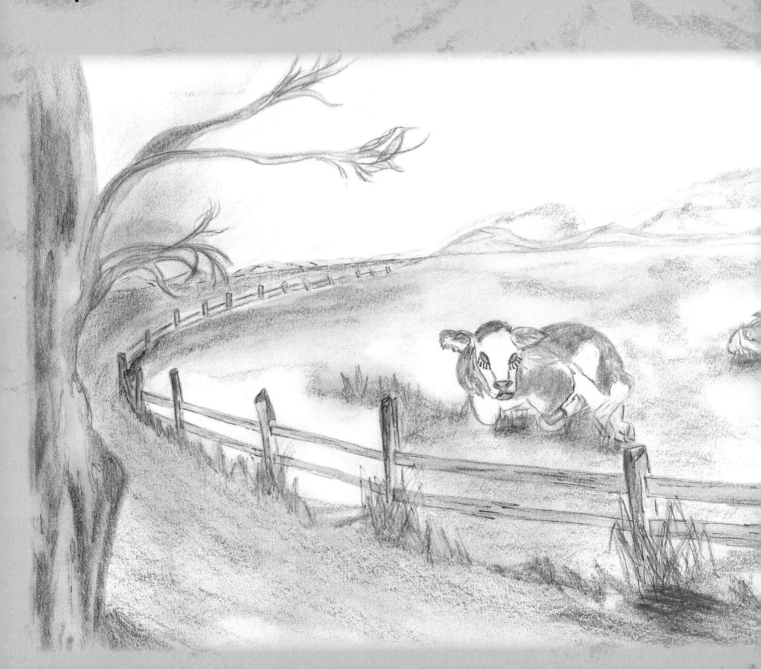

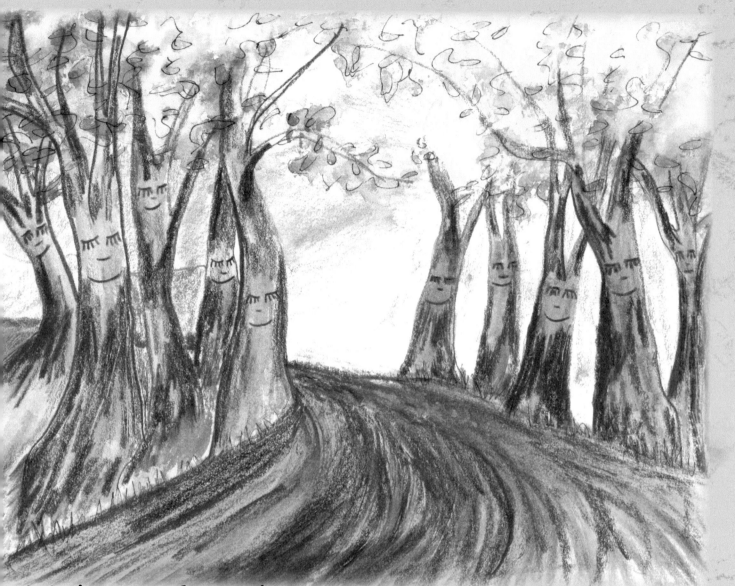

Wake up, forest!
Help us breathe.
You give us air
all the day long.

Wake up, skunk!
Make the first move.

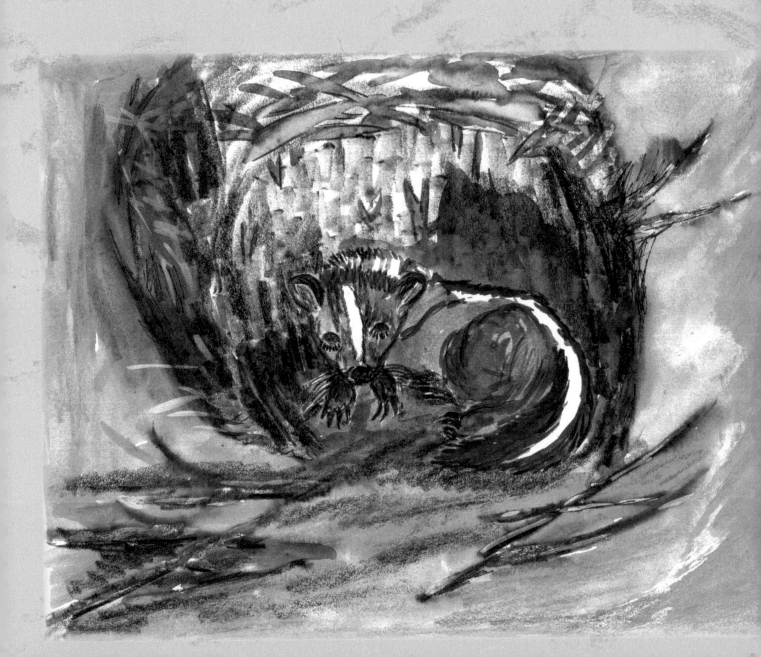

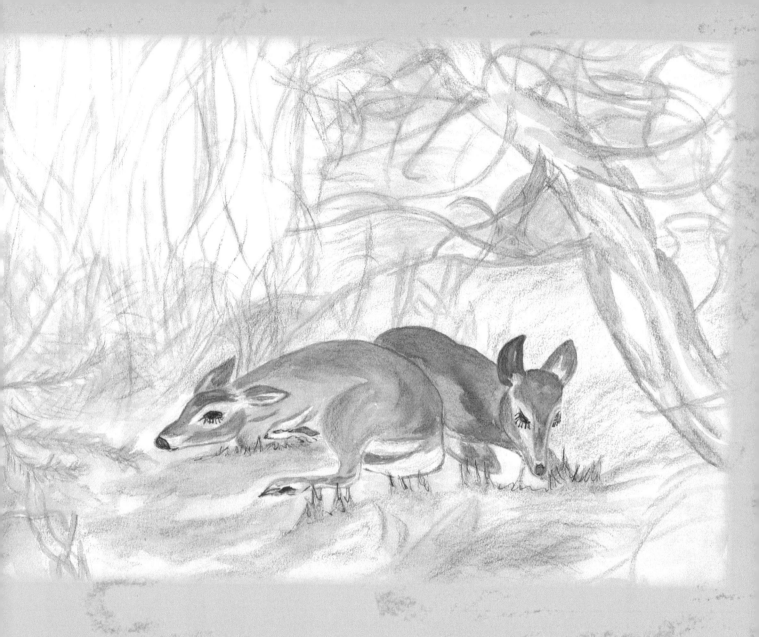

Warn the deer
their enemy is near.

Wake up, creatures
big and small.
Time to play!
Give Mr. Owl a call.

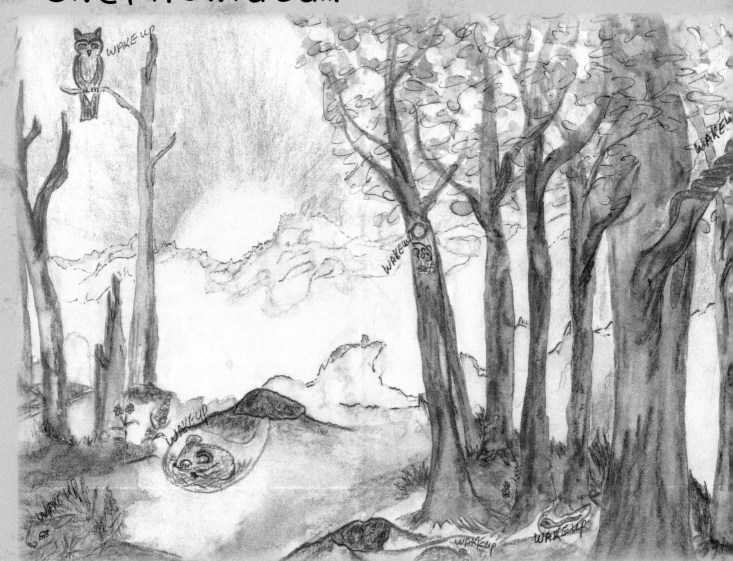

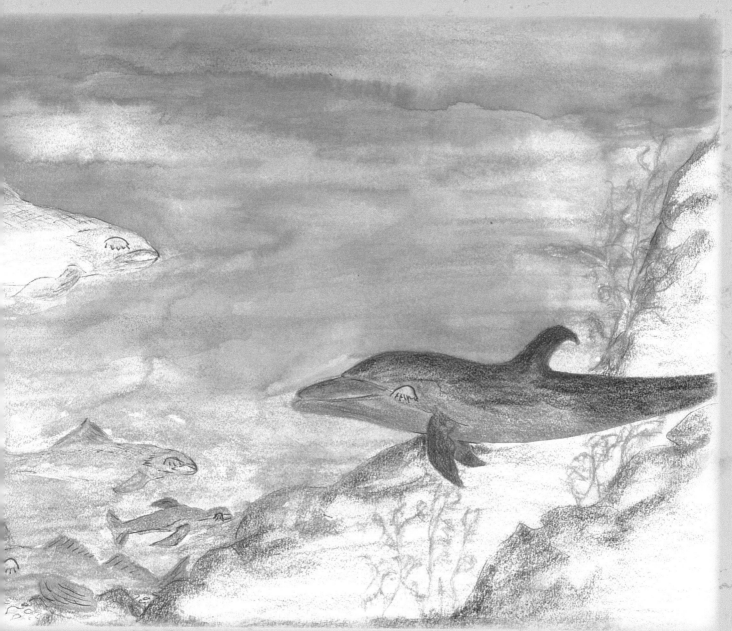

Wake up, ocean!
Make the water stir.

Also Mr. Lobster!

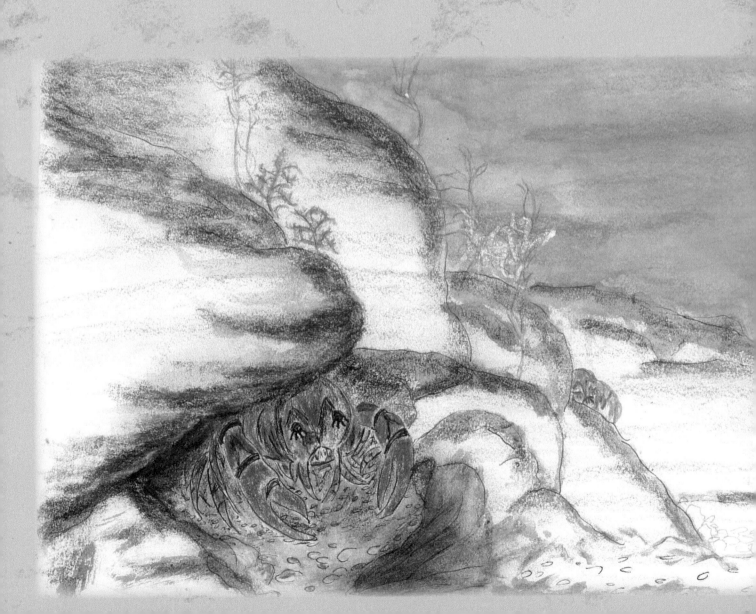

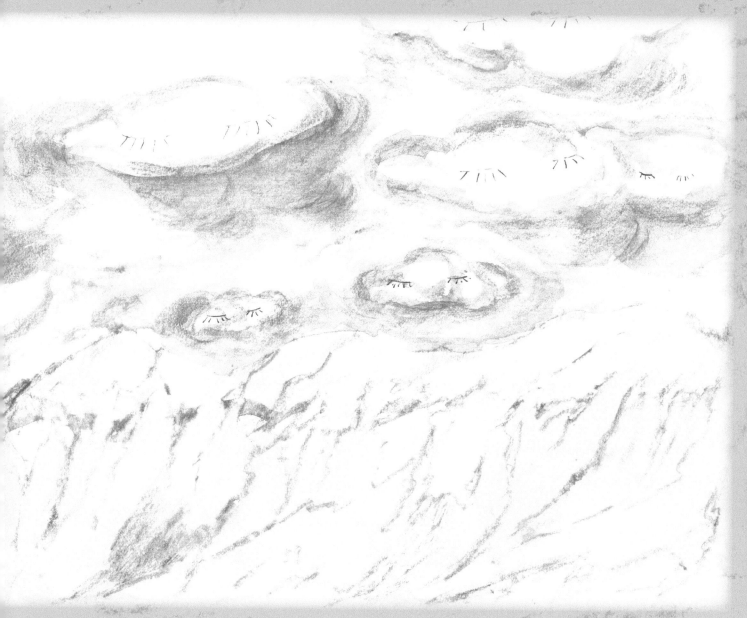

Wake up, clouds,
as you climb over the mountains.

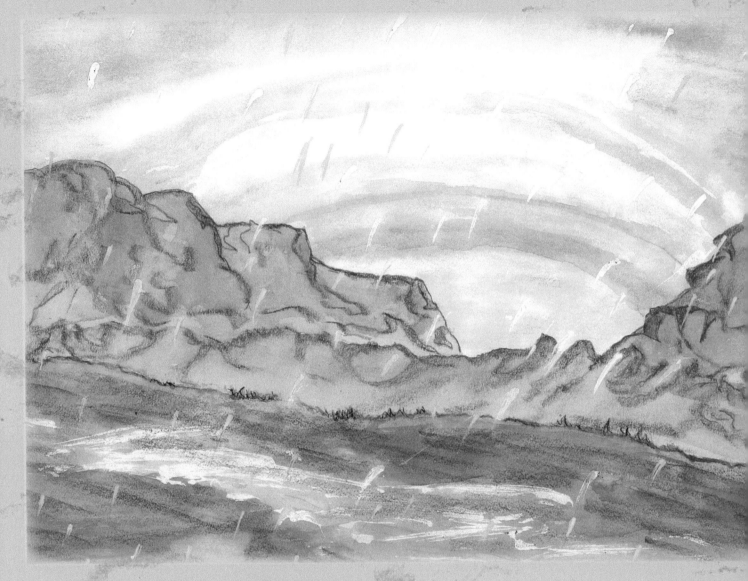

Let your raindrops fall
with a soft, quiet hum.
A beautiful rainbow
that glows through the sun.

Thank you, sun,
for all you have done.
Your golden glow
did so much for each one.

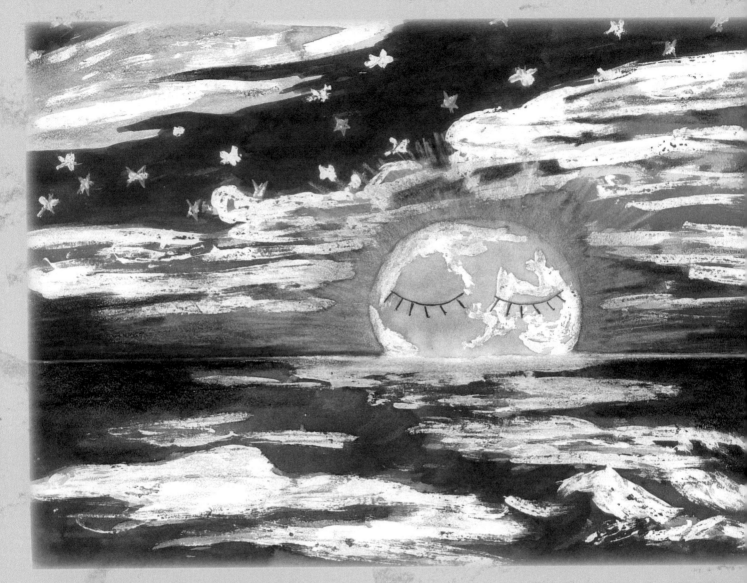

Wake up, moon!
It's your turn now.
Tuck in each creature,
big and small.

Good night, friends!
My job is done here.
But the other side of the world
is waiting for me to rise.

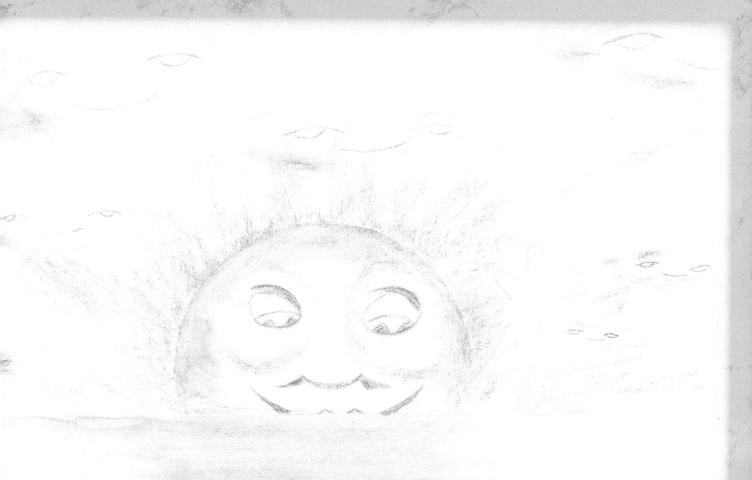

The earth is our friend.
We must take care of each other.

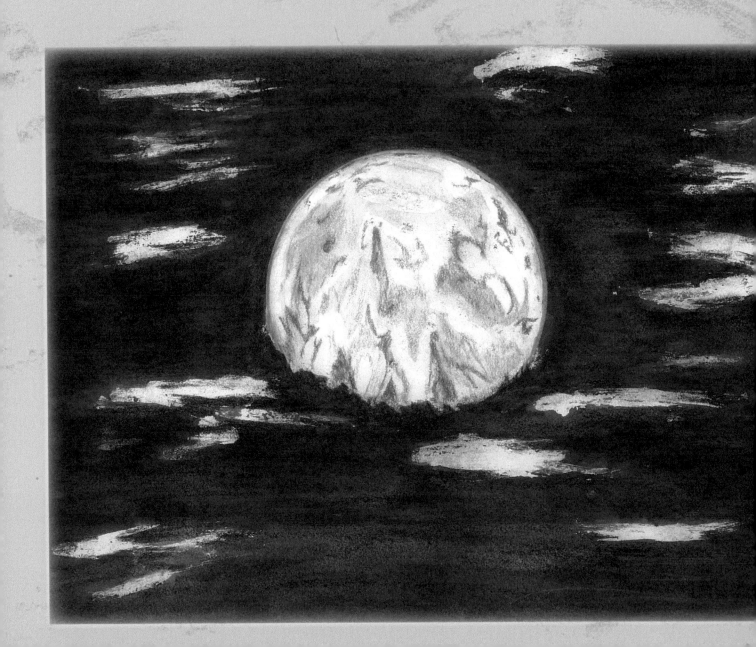

Wake Up!

Printed in the United States
by Baker & Taylor Publisher Services